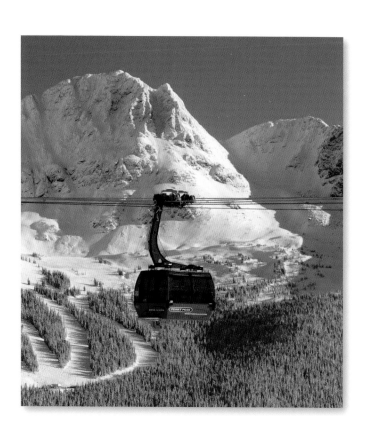

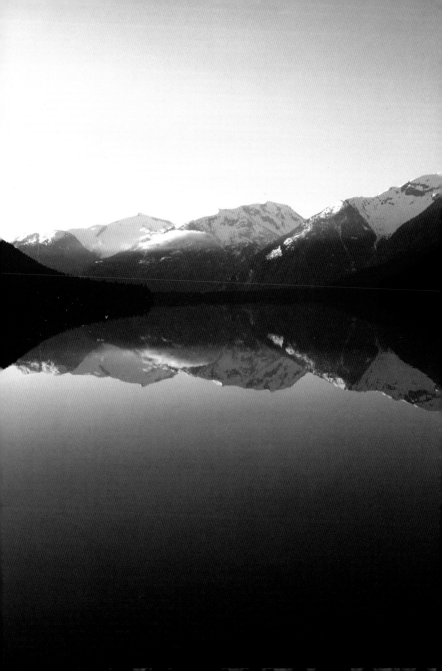

The Little Gift Book *of*
WHISTLER

whitecap

Written by Laura Farina
Photo selection and interior design by Jan Westendorp
Edited by Paula Ayer and Grace Yaginuma
Front cover photograph by Rob Cocquyt / chilledimages.com
Cover design by Claire Leila Philipson and Jan Westendorp

Complete photo credits listed on page 96.

Printed in China

Library and Archives Canada Cataloguing in Publication

Farina, Laura, 1980–
 The little gift book of Whistler / Laura Farina.

ISBN 978-1-55285-991-9

 1. Whistler (B.C.)—Pictorial works. I. Title.

FC3849.W49F37 2009 971.1'31 C2008-906177-2

The publisher acknowledges the financial support of the Government of Canada through the Book Publishing Industry Development Program (BPIDP) and the Province of British Columbia through the Book Publishing Tax Credit.

09 10 11 12 13 5 4 3 2 1

Whistler's glacier-capped mountains and lake-studded valleys attract more than two million tourists annually. And no wonder. For those who seek adventure and love the outdoors, there is always something to do here. Winter is dominated by skiers and snowboarders; summer brings windsurfers, kayakers, hikers, and mountain bikers attracted by the lakes, rivers, and trails that criss-cross the valleys. Whistler has become a world-class resort destination and will welcome thousands of visitors when it hosts the 2010 Olympic and Paralympic Winter Games. It can be hard to believe that less than one hundred years ago, there was just a small fishing lodge here with no road access or electricity.

John Millar was one of the first settlers in the area, a trapper who ran a stopping house on the Pemberton Trail. He met Alex Philip during a trip to Vancouver in 1911, and invited him and his wife Myrtle to experience the excellent fishing on the many lakes near his cabin. The trip transformed the valley. The Philips fell in love with the area and returned to open a fishing lodge on the shores of Alta Lake. Soon, Rainbow Lodge was considered the best resort west of Banff, and hundreds of people came to Whistler with fishing rods in hand.

It wasn't until the 1960s that the mountains took centre stage. A group of Vancouver businessmen formed the Garibaldi Olympic Development Association (GODA) to develop Whistler as the host of a future Olympic Games. At the time there was no electricity, piped water, or sewers in the area, and the site was inaccessible by road. Still, ski trails were built on Whistler Mountain in the area now known as Creekside, and the mountain opened as a ski hill in 1965. Roads were built around this time, the town site was developed in 1978, and ski runs on Blackcomb Mountain opened in 1980—all this despite four separate unsuccessful bids for the Olympics.

Today, visitors from around the world enjoy the 200 runs on Whistler and Blackcomb, and the town site is known for its forward-thinking urban planning. It is fitting that of all the ski runs, Creekside is being selected as the site for the alpine ski competitions at the 2010 Olympic and Paralympic Games—a small nod to Whistler's past, and a realization of the region's fifty-year Olympic dream.

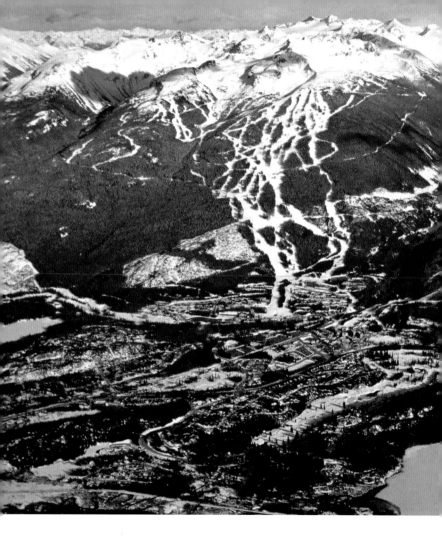

The resort village of Whistler is nestled in a valley carved by the Green River and flanked by glacial mountains on all sides. Behind the village sit Whistler

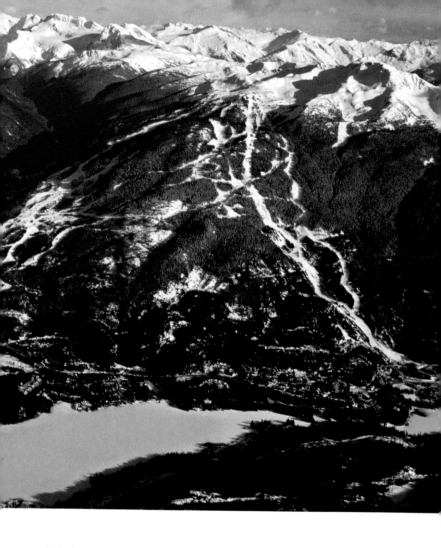

and Blackcomb mountains, home to some of North America's best ski runs. Beside the village, the frozen waters of Alta Lake beckon skaters and ice fishers.

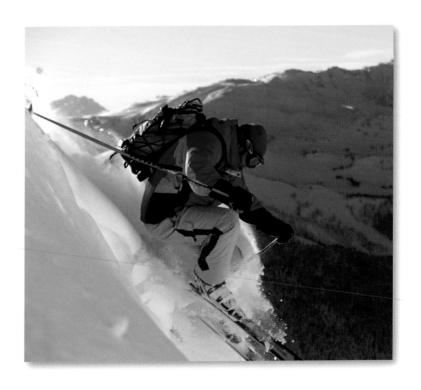

Whistler and Blackcomb have the highest vertical rises of any ski mountain in North America. Breathtakingly steep drops and wide open alpine bowls make the mountains a dream destination for advanced skiers.

Two kilometres south of Squamish, the crystal-clear water of Shannon Creek tumbles over cliffs to form Shannon Falls, the third-highest waterfall in British Columbia.

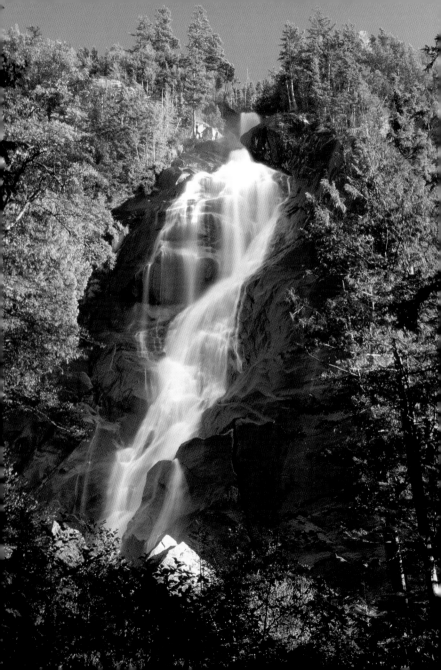

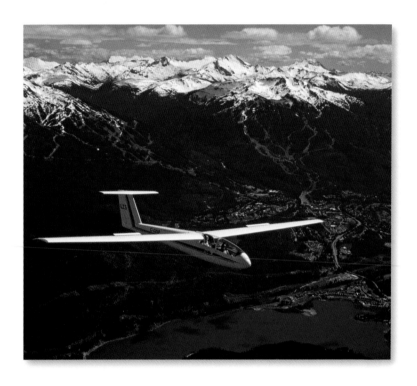

Soaring over the mountains in gliders, aircraft that use
rising air to soar without the use of a motor, is a popular
way to take in the majestic scenery.

The village of Whistler has approximately ten thousand
permanent residents, but the population can swell to as
many as forty thousand in peak seasons.

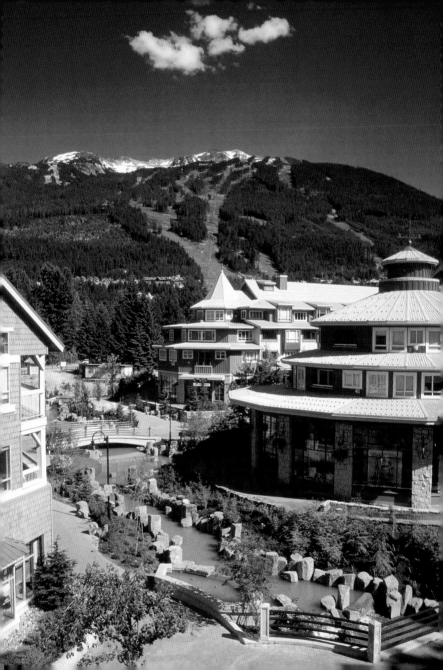

After a day on the slopes, hungry skiers can get a bite to eat at one of Whistler's more than ninety bars and restaurants.

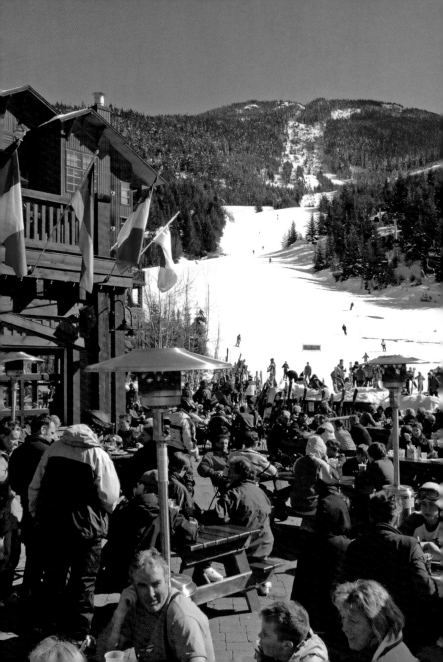

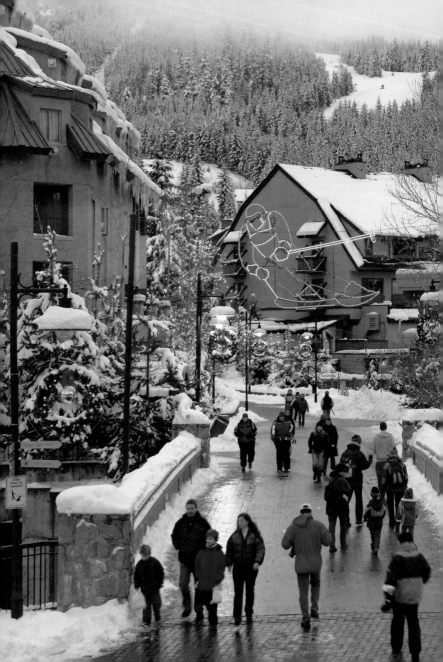

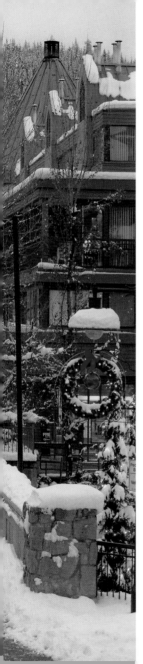

Whistler's carefully
planned pedestrian-
only village allows
people to wander
freely among the
shops and restaurants.

Whistler and
Blackcomb mountains
have thirty-eight
ski lifts, which can
transport over sixty-
five thousand skiers
and snowboarders
every hour.

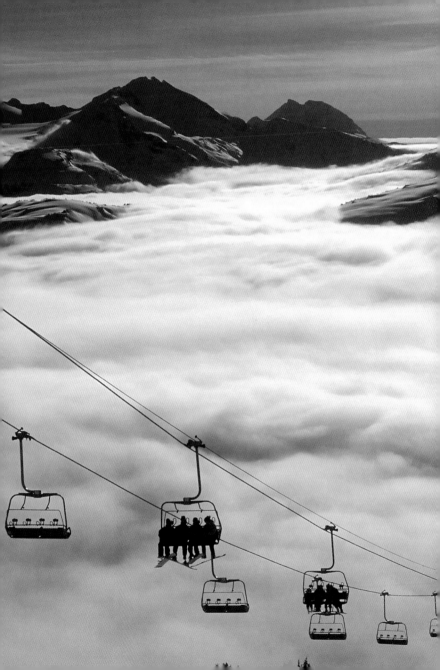

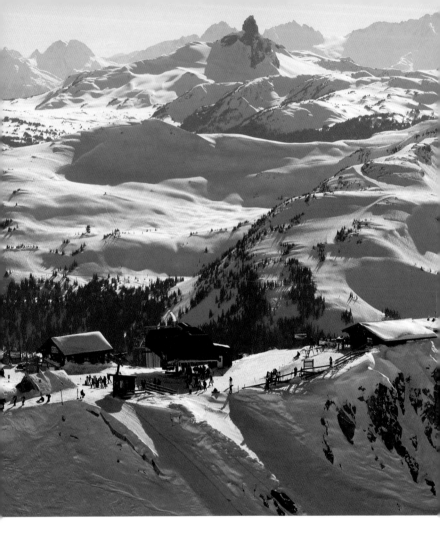

The weather in Whistler is ideal for skiing, with reliable snow conditions and moderate temperatures throughout the winter. On average, Whistler receives

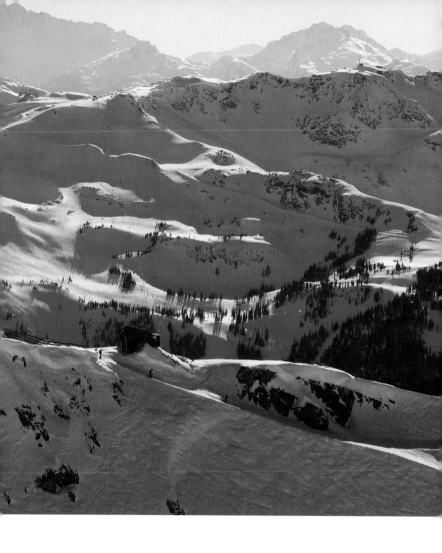

an annual snowfall of 10 metres and enjoys temperatures that rarely dip below minus 10 degrees Celsius.

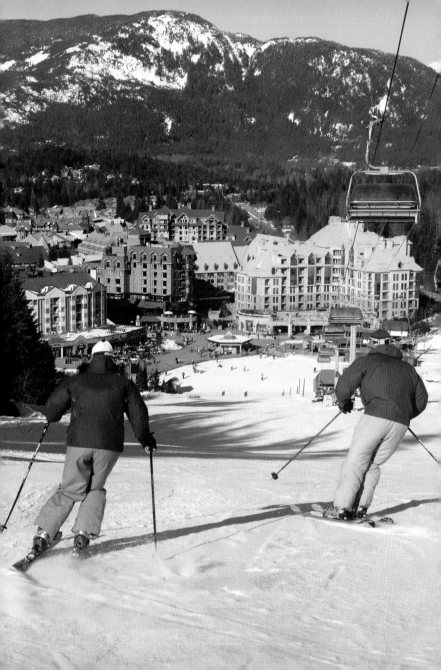

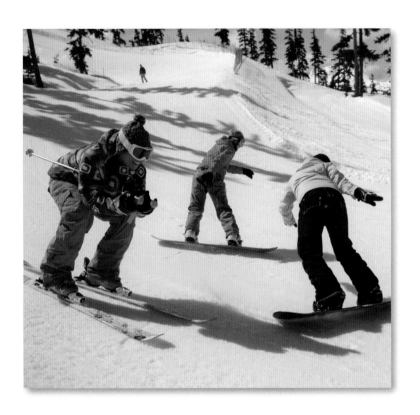

The more than three thousand
hectares of skiable terrain at Whistler
and Blackcomb offer something for
skiers at every level. Of the mountains'
two hundred ski runs, 20 percent are
designed for beginners, 55 percent are for
intermediate skiers, and 25 percent are
for the advanced.

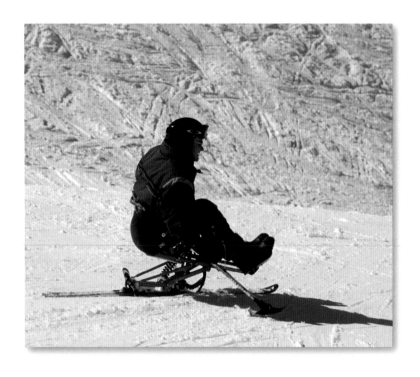

Whistler's Adaptive Sports Program aims to make winter sports accessible to people of all abilities. Its ski program teaches people with limited lower-body strength or those who use wheelchairs to ski using monoskis and other adaptive equipment.

About 80 percent of the world's heli-skiing takes place in British Columbia. The sport offers a unique opportunity to enjoy spectacular snow conditions year-round on the peaks and glaciers that surround Whistler.

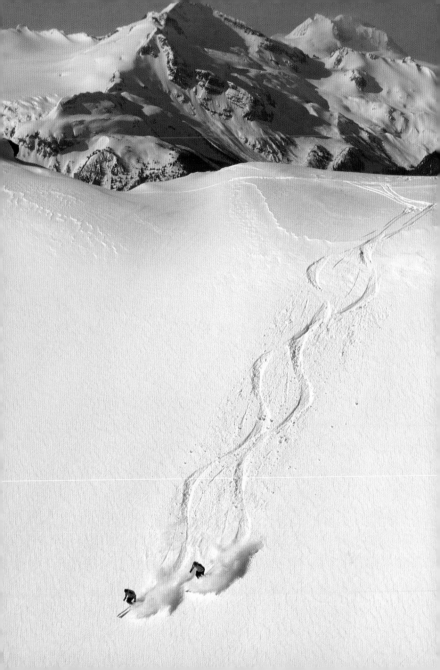

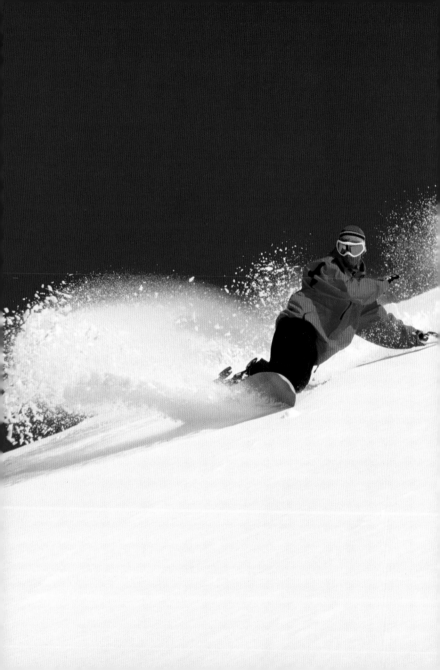

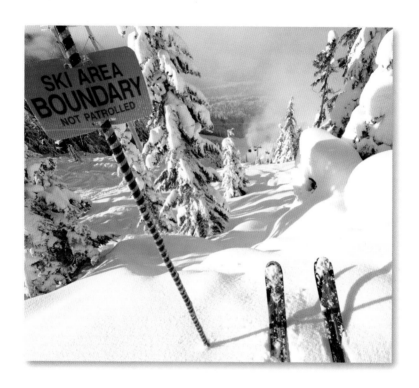

Backcountry skiing can be challenging and rewarding, and those requiring emergency assistance can be charged for their rescue. Proper education and equipment are a must, as is a qualified guide.

High in the mountains, Whistler's sprawling alpine bowls offer snowboarders no end of powder.

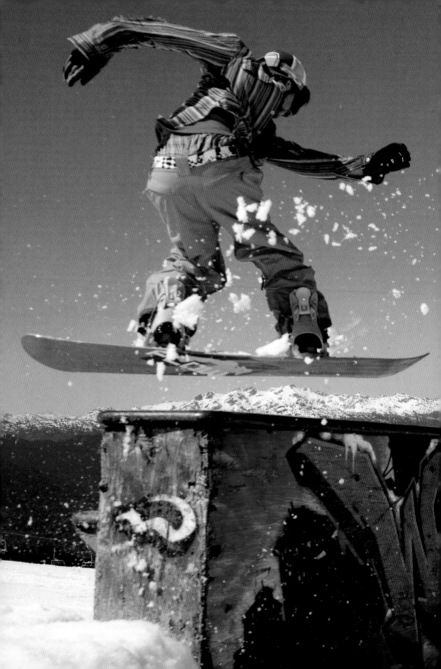

The Terrain Parks on Whistler and Blackcomb feature banks, rails, and fun boxes for snowboarders to practise their tricks. The parks are designed to progress in difficulty, so snowboarders can master one park before moving on to the next.

27

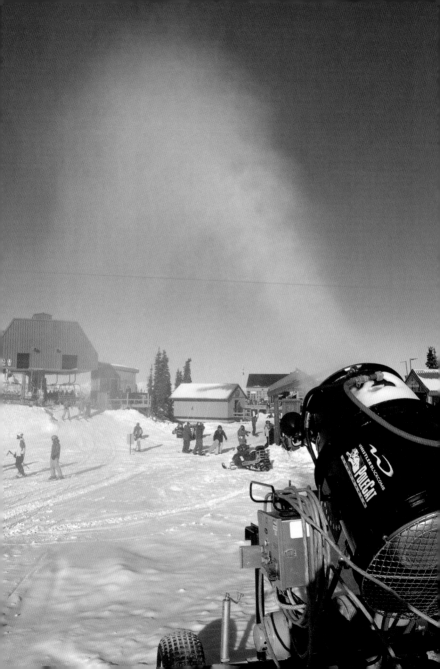

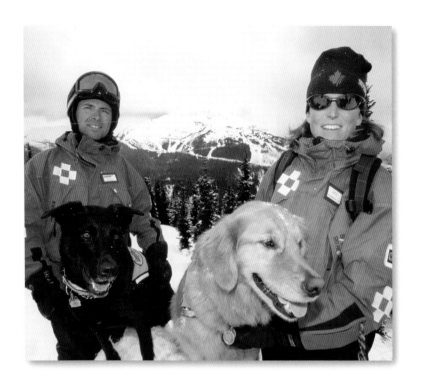

Whistler and Blackcomb use a team of thirteen avalanche dogs during search and rescue operations. The dogs range from puppies just entering training to experienced rescuers and are trained through a system based on rewards for tasks accomplished. The dogs and their handlers are part of the Canadian Avalanche Rescue Dog Association, a volunteer, not-for-profit organization.

Whistler relies on an arsenal of 269 snow-making guns that convert nearly five hundred million litres of water into 260 hectares of snow annually.

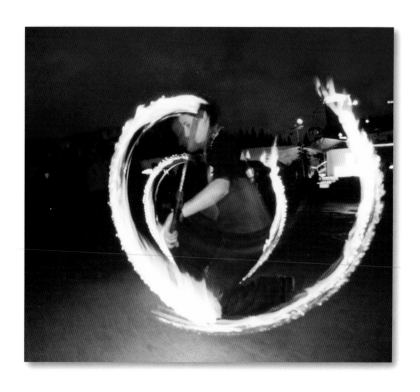

Snowboarders flip and twist through a ring of fire in Whistler's Fire and Ice Show. The show also features fire spinners and a pyrotechnic display.

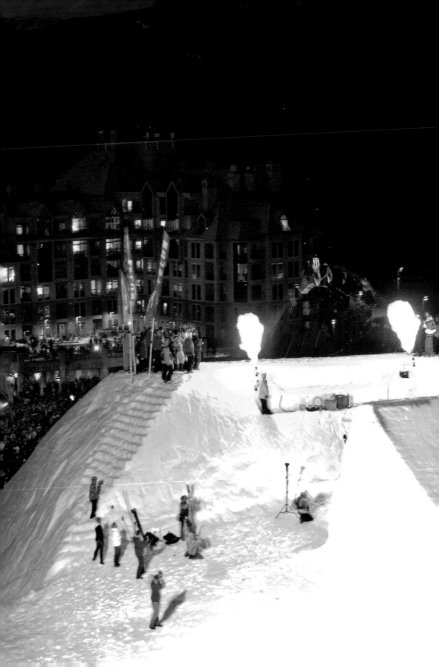

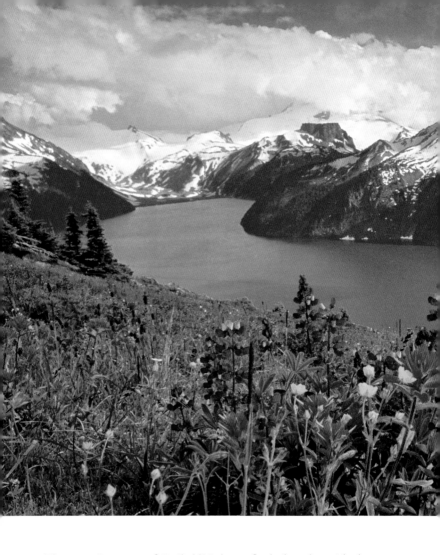

The turquoise waters of Garibaldi Lake are flanked on three sides by volcanoes. Lava flows from Mount Price and Clinker Peak created the lake

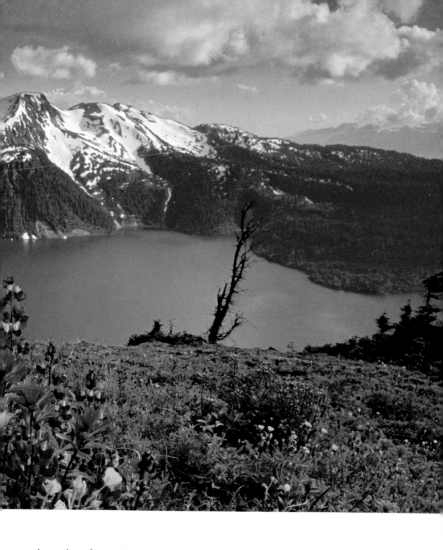

when a lava formation known as The Barrier dammed the valley,
trapping water inside.

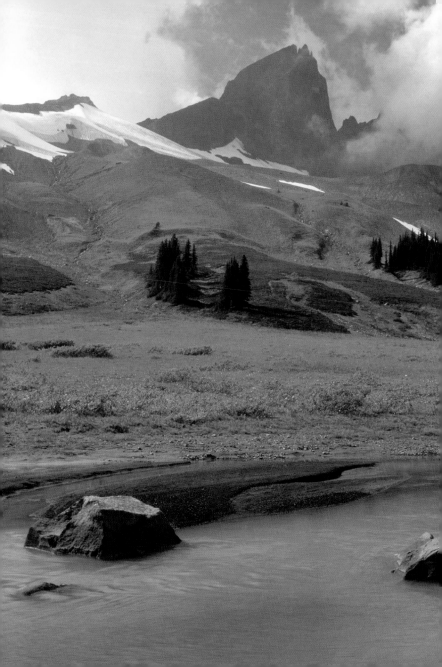

In Squamish legend, the rough edges and black marks on Black Tusk came from Thunderbird, who created lightning and thunder from the rock's peak.

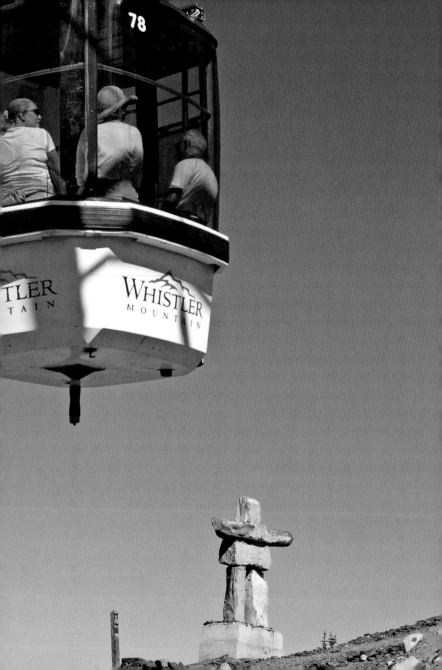

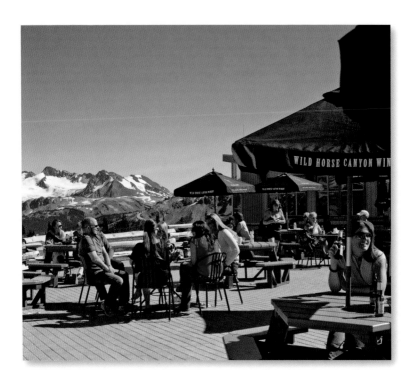

Outdoor cafés and patios are great places to take in the scenery or partake in Whistler's second-favourite pastime—people-watching.

Gondola passengers get a great view of the inukshuk on Whistler Mountain. Inukshuks are traditionally used as trail markers and navigational symbols by the Inuit people. The rock structure has come to symbolize friendship and welcoming.

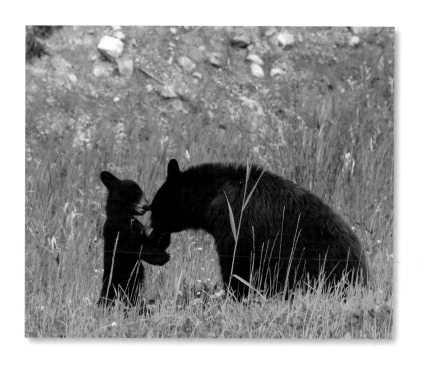

Eight black bear families live on Whistler and Blackcomb mountains. A team of biologists track their eating, mating, migration, and hibernation activities to improve conservation initiatives and help preserve their habitat.

Strapped to a harness, visitors drop twenty storeys from start to finish in the course of this popular Whistler adventure known as "ziplining." Sailing over temperate ancient coastal rainforest, riders can reach speeds of 80 kilometres an hour.

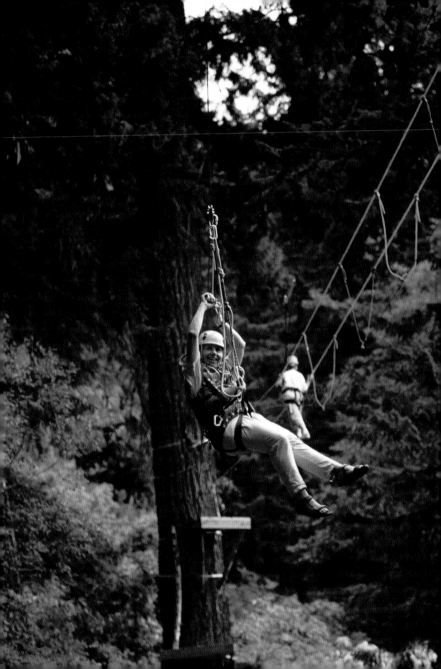

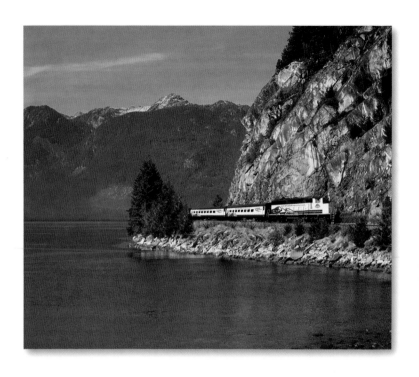

The Whistler Mountaineer™ train leaves daily from
Vancouver between May and October. Hugging
the oceanfront, it passes through canyons and up
steep mountain grades, providing passengers with
breathtaking views on the three-hour trip.

The Sea-to-Sky Highway, which connects Vancouver
to Whistler, winds its way along the Pacific Coast.
Voted the most romantic road in the world, it passes
through five distinct bioclimatic zones.

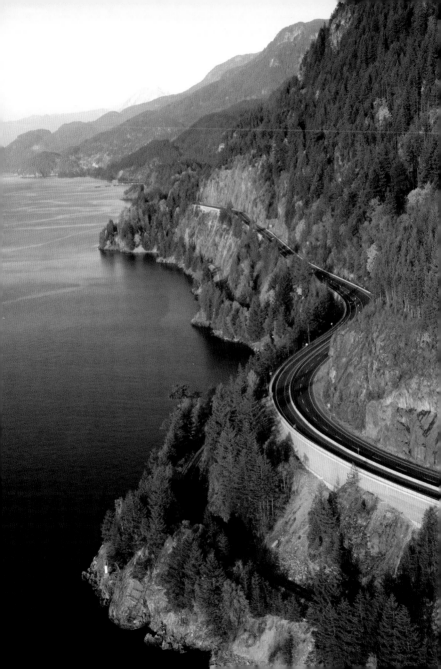

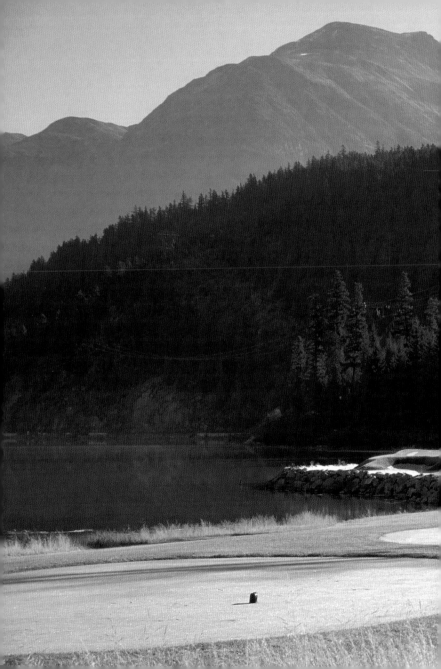

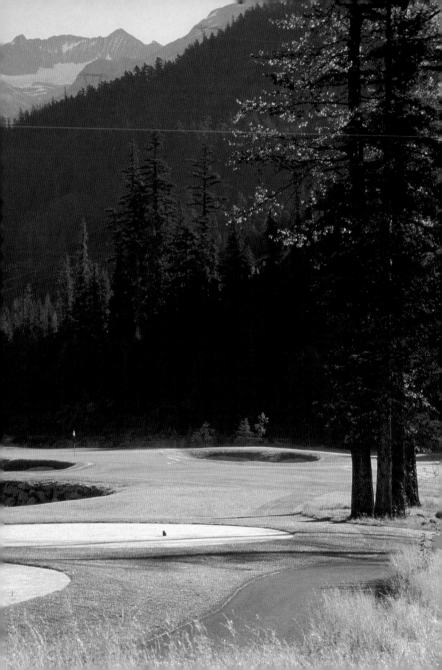

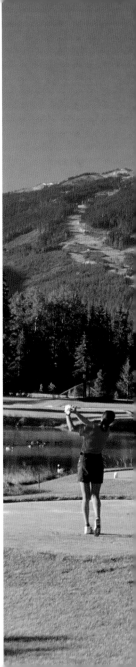

(PREVIOUS)
Jack Nicklaus, one
of the greatest of the
professional golfers,
designed the eighteen-
hole Nicklaus North
Golf Course, which
features impeccably
manicured greens
and water hazards on
fifteen holes.

Whistler was rated
Canada's number-
one golf destination
by *Golf Digest*
magazine. Its four
award-winning
golf courses offer
challenging play and
spectacular scenery.

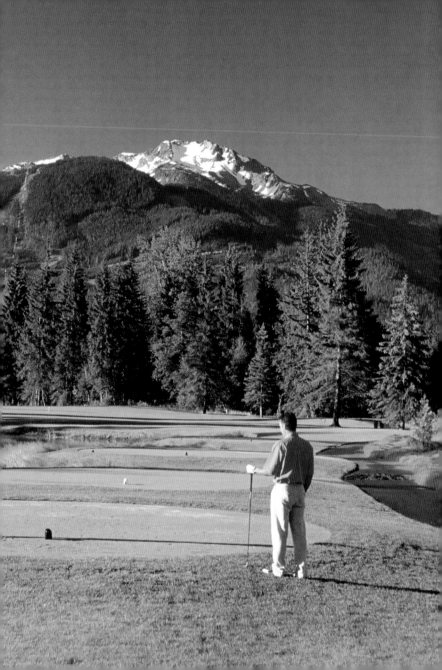

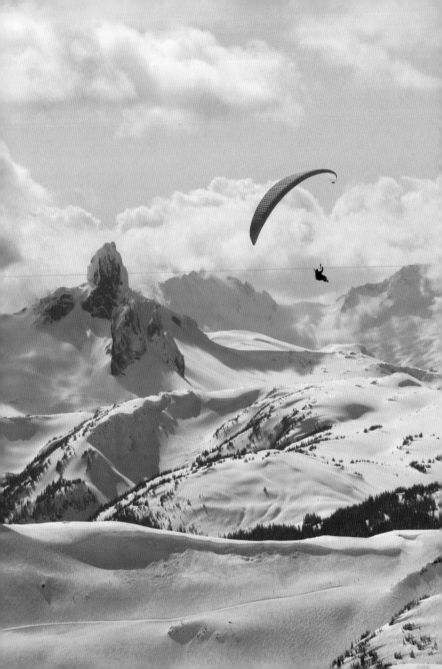

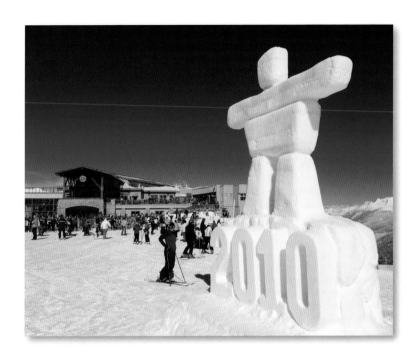

Whistler was named "Host Mountain Resort" for the 2010 Olympic and Paralympic Winter Games. Over half of the medal competitions will be won and awarded in Whistler.

The brightly coloured sails of paragliders and hang-gliders are a common sight in Whistler. Conditions in the area are perfect for the sport, with peaks sometimes towering ten thousand feet above the valley floor.

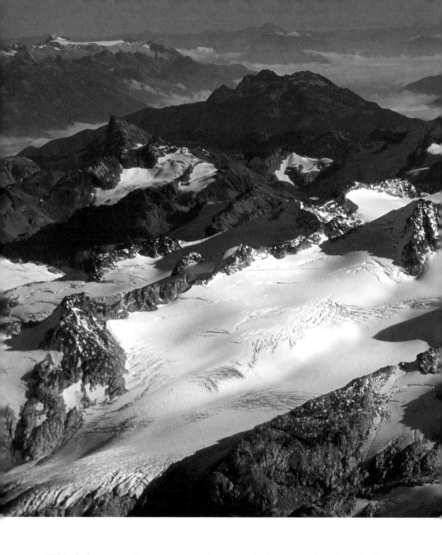

Whistler's mountains are among the most glacier-covered regions in the world. The glaciers date back to the last ice age, making them approximately

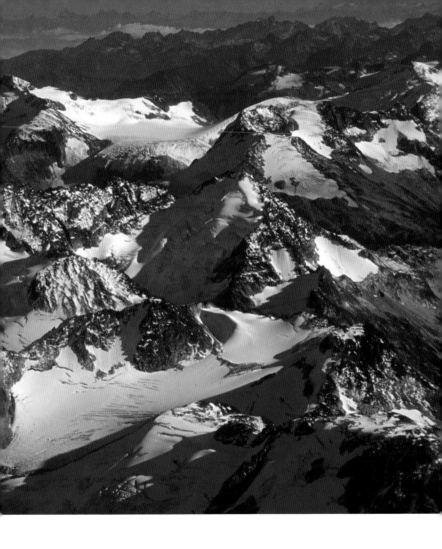

120,000 years old. Those on hiking tours are taught to use crampons and an axe to successfully navigate the wide expanses of snow and ice.

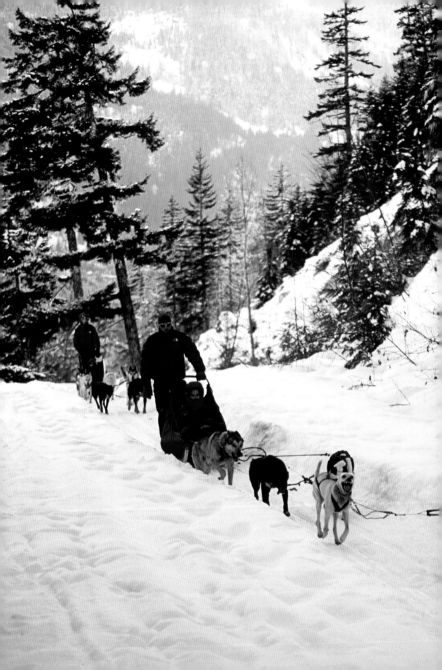

Teams of huskies pull sleds through the wilds of Whistler's backcountry. Sled dogs are chosen for their endurance and speed.

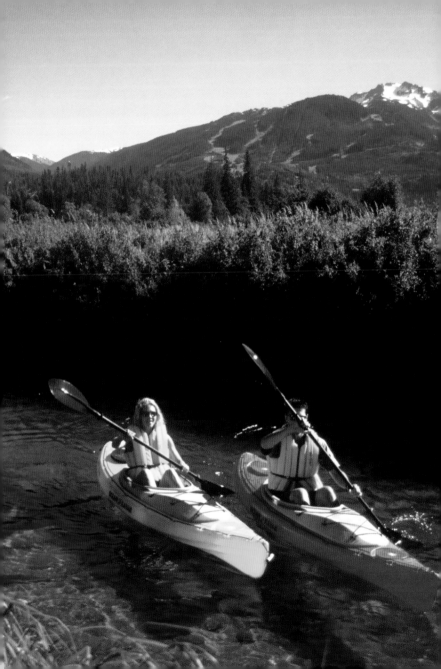

Paddlers take a
leisurely kayaking
ride on the River
of Golden Dreams,
which connects Alta
Lake to Green Lake.
At the mouth of the
river sits Rainbow
Lodge, a fishing resort
and one of the first
permanent buildings
in the area.

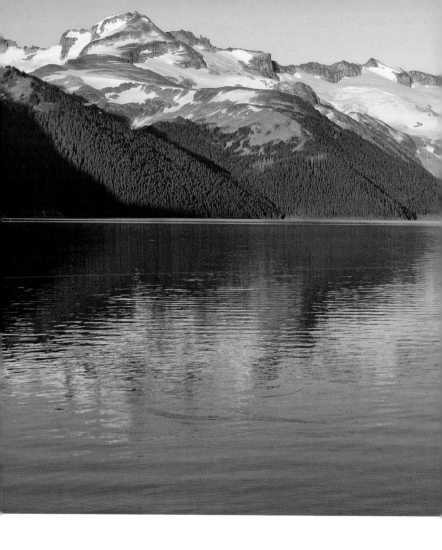

Garibaldi Lake is a popular spot for fly-fishing. From July until late fall, rainbow trout can be caught in the turquoise waters, and the gravelly mouths

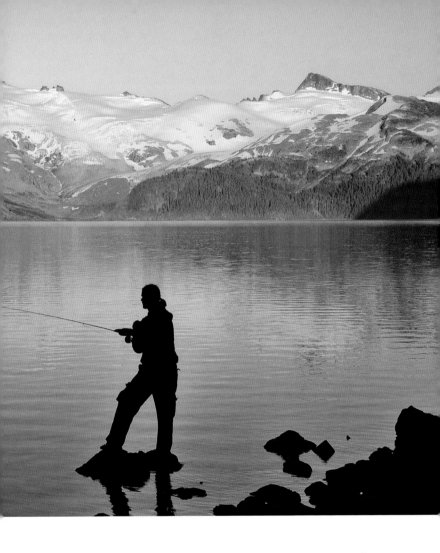

of the streams that feed the lake attract spawning fish. Although usually small, trout up to four pounds have been reported.

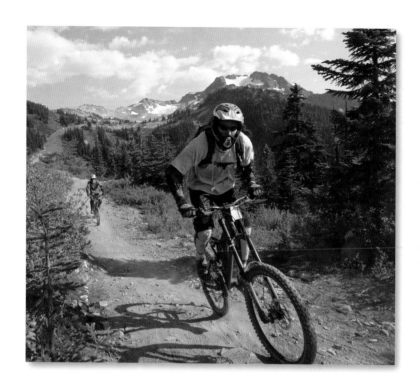

An incredible variety of terrain draws
mountain bikers from around the
world to Whistler Mountain Bike
Park. Gondolas that are used to
transport skiers during the winter
are outfitted with bike racks to take
riders to the top of the mountain.

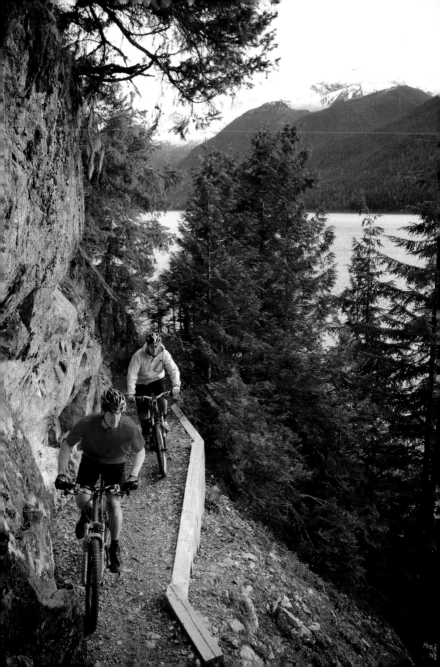

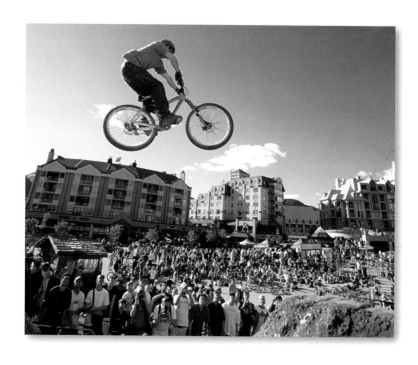

The Kokanee Crankworx mountain bike festival is held annually. Featured is a dizzying display of gravity-defying tricks over the course of nine days.

Four-wheel mountain bikes are becoming increasingly popular in Whistler, for riders both with and without disabilities. These bikes feature disc brakes and no gears or pedals.

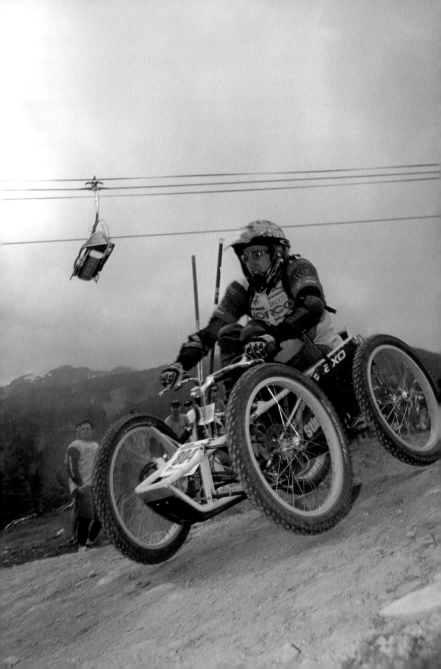

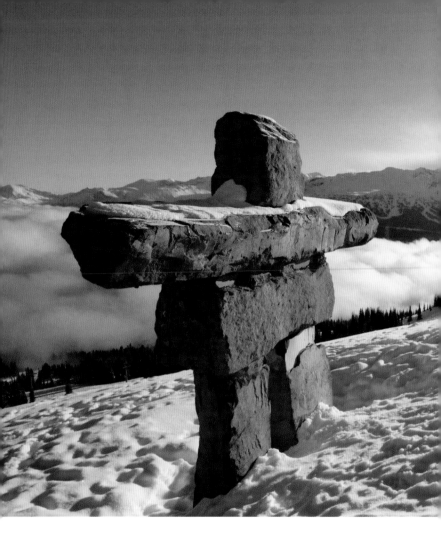

The inukshuk was chosen as the emblem for the 2010 Olympic and
Paralympic Winter Games. Named *Ilanaaq,* the Inuit word for friend,

the symbol was chosen to represent friendship, hospitality, strength,
teamwork, and the vast Canadian landscape.

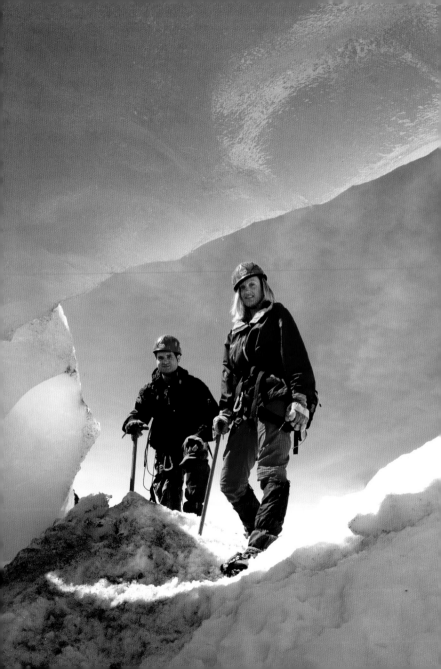

The Whistler Sliding Centre is the host for the bobsleigh, luge, and skeleton events at the 2010 Olympic and Paralympic Winter Games. The venue features a new 1,450-metre competition-length concrete sliding track.

Not just for skiers and snowboarders, Whistler also attracts ice climbers, who tackle Whistler's many glaciers with picks in hand.

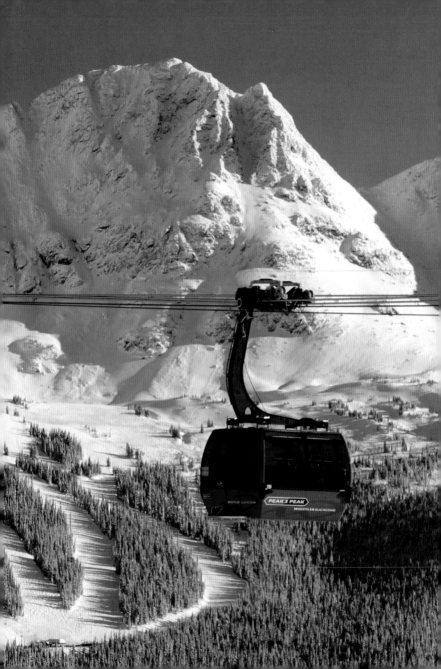

The Peak 2 Peak gondola links Blackcomb and Whistler mountains. Completed in 2008, it is the highest lift in the world, and also contains the longest unsupported span of cable of any gondola ever created.

Children play pick-up hockey on the frozen surface of Green Lake. Emerald Estates and Alpine Meadows—two of Whistler's residential neighbourhoods—border the lake, which is both the longest and most northerly in the valley.

(OVERLEAF) During Whistler's annual Telus World Ski and Snowboard Festival, over sixty bands play in a natural outdoor amphitheatre at the base of the gondolas, providing an ongoing soundtrack for the 250,000 attendees.

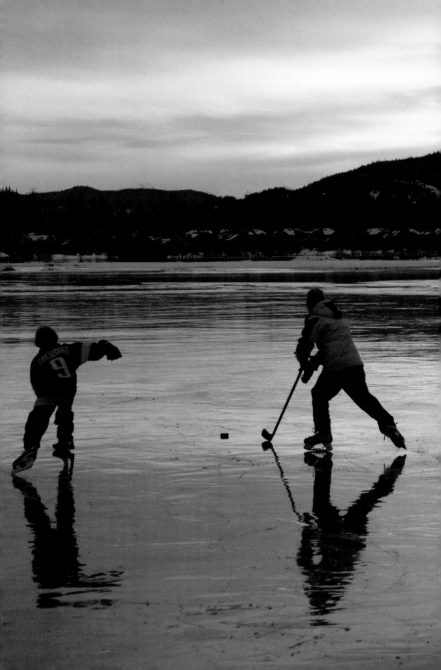

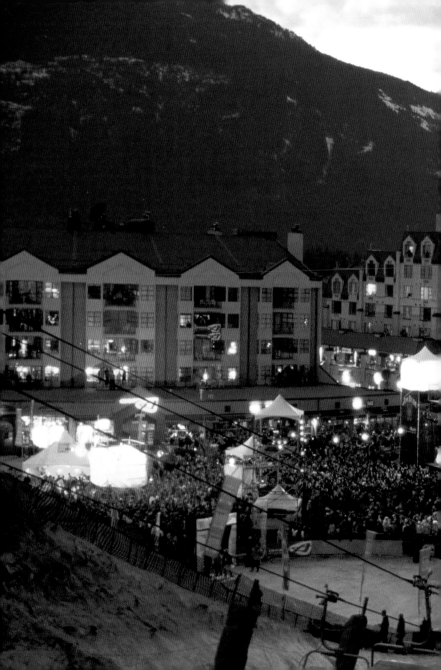

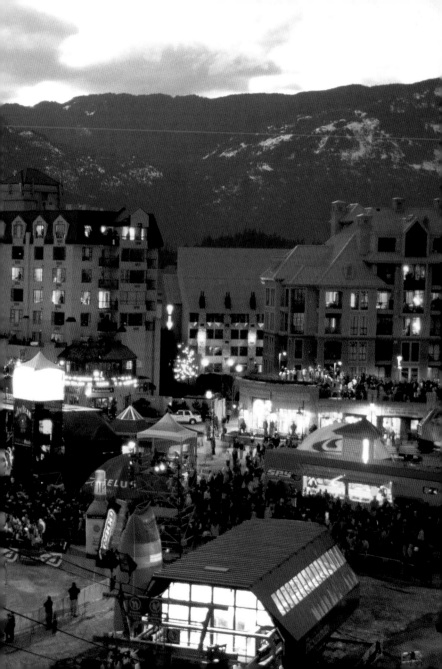

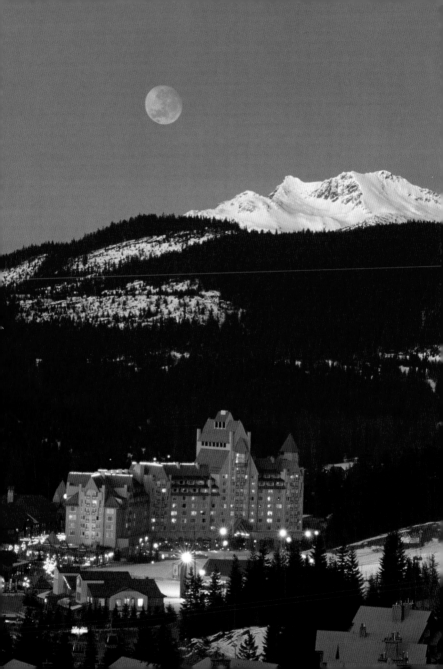

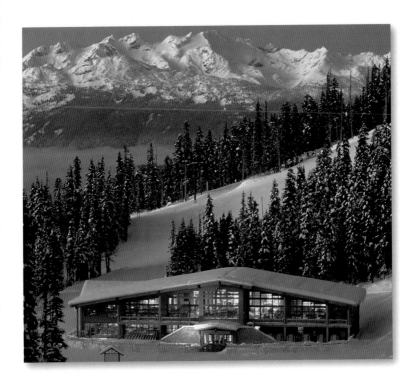

Situated halfway up Blackcomb, the Glacier Creek Lodge offers tired skiers and snowboarders a place to rest and enjoy a warm drink.

Designed to evoke Canada's luxurious railway hotels, the Fairmont Chateau Whistler opened its doors in 1989. The hotel features a golf course, health club, and spa, and bills itself as a resort within a resort.

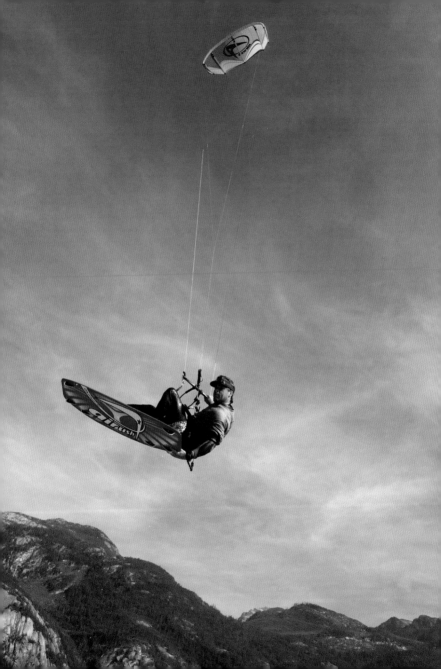

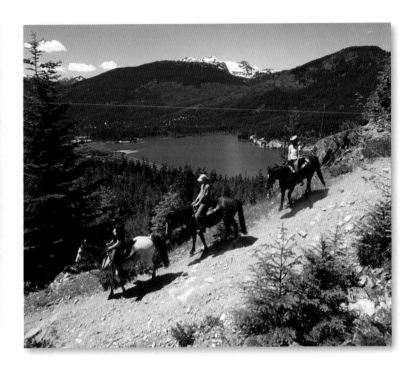

Many visitors opt to take in the grassy meadows, mountain paths, and forest trails surrounding Whistler on horseback.

A kiteboarder catches some air on one of the area's many lakes. The sport, which has evolved dramatically in recent years, most often involves a rider strapped to a performance kite being pulled through the water on a small surfboard.

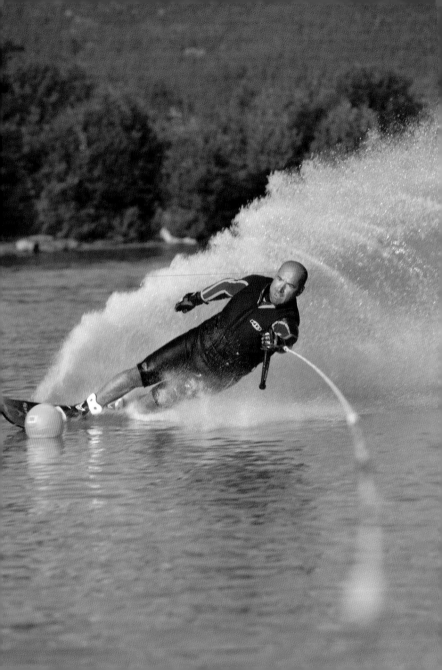

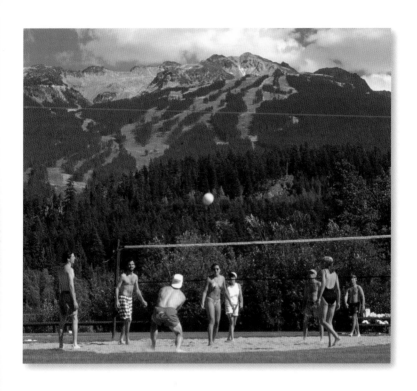

Whistler is not just a winter resort;
summer sports from beach volleyball
to waterskiing are enjoyed when the
weather is warm.

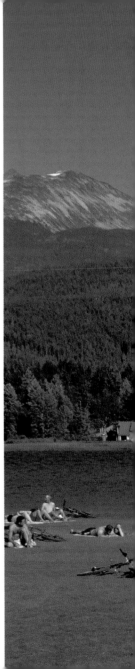

Visitors and locals
soak up the sun at
Rainbow Park on
Alta Lake. The park
marks the spot where
Alex and Myrtle
Philip established
the Rainbow Lodge
in 1914. The four-
bedroom lodge, which
quickly expanded
with cabins to
accommodate up to
a hundred visitors,
brought the first
tourists to the area.

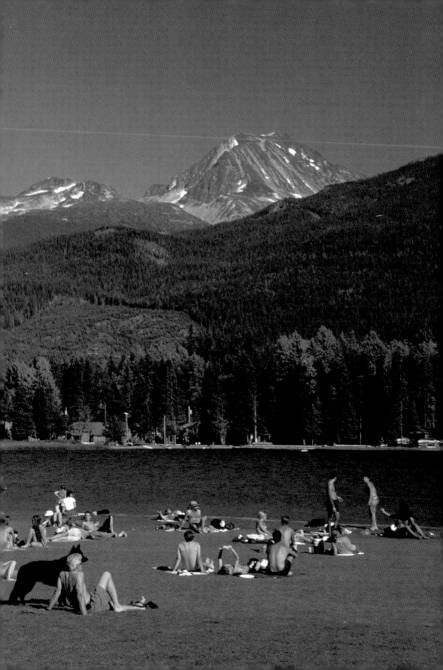

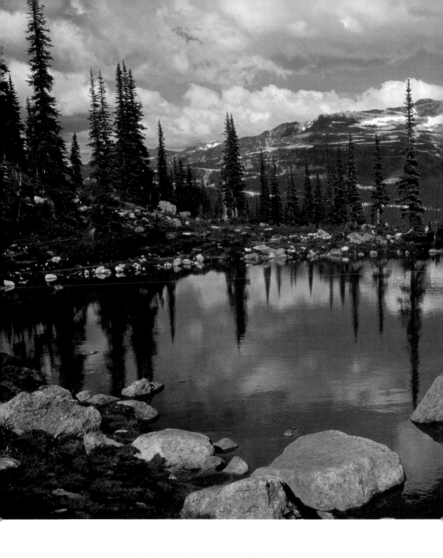

For many years Whistler was known as a fishing destination. It was only in the early 1960s that the area became known for its skiing, when the

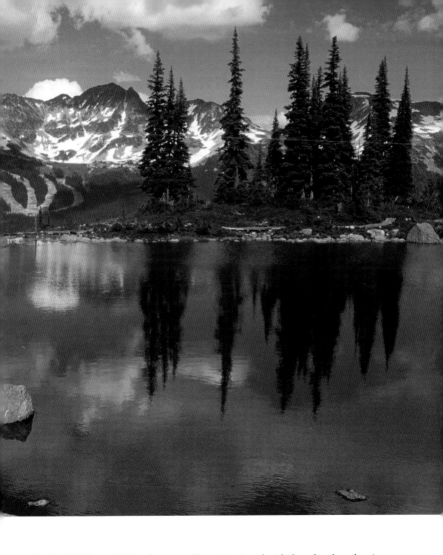

Garibaldi Olympic Development Organization decided to develop the site as part of their bid to bring the Olympics to British Columbia. At the time there was no road, electricity, or piped water in the region.

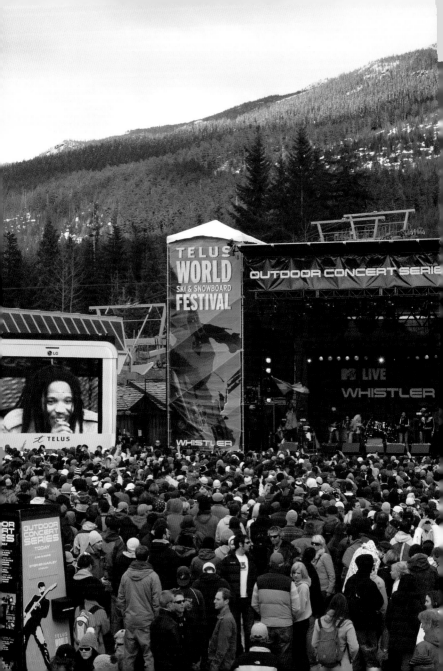

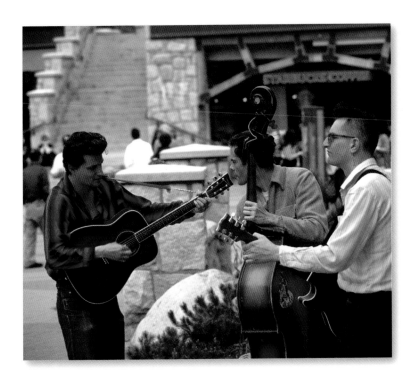

With its beautiful mountain backdrop, it's no wonder outdoor concerts are everywhere in Whistler. From large outdoor events like the Telus World Ski & Snowboard Festival to buskers on street corners, it seems like there's always music in the air.

Whistler's active nightlife includes
dance clubs, DJs, and live music every
night of the week.

The winds that funnel
down Howe Sound
make Whistler and
nearby Squamish
favourite places for
windsurfing.

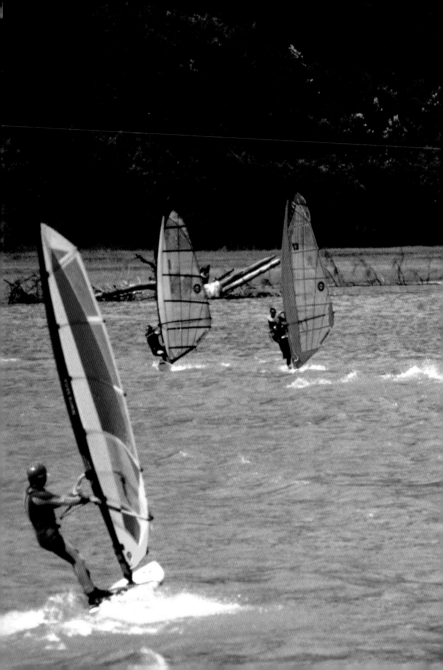

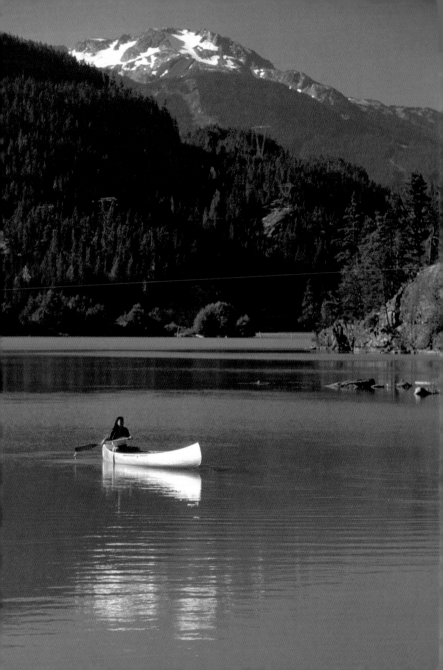

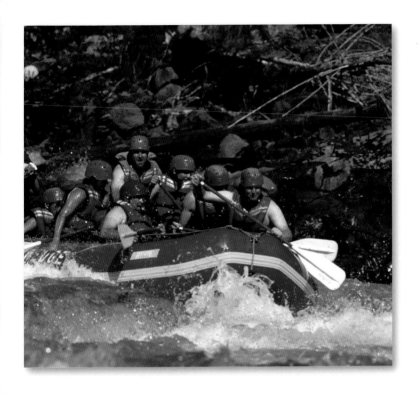

When the snow melts, Whistler's many lakes are as much an attraction as its mountains. From leisurely canoe trips to thrilling whitewater rafting expeditions, there's something for every taste.

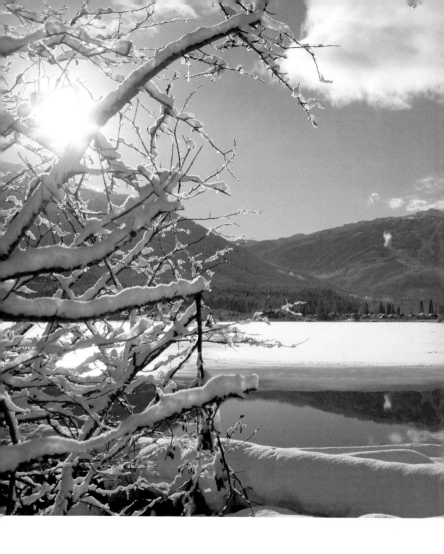

The view of Whistler Mountain from Alta Lake captures the area's past and future. In less than one hundred years Whistler has gone from a tiny fishing